FIELDS OF VISION
The Photographs of Esther Bubley

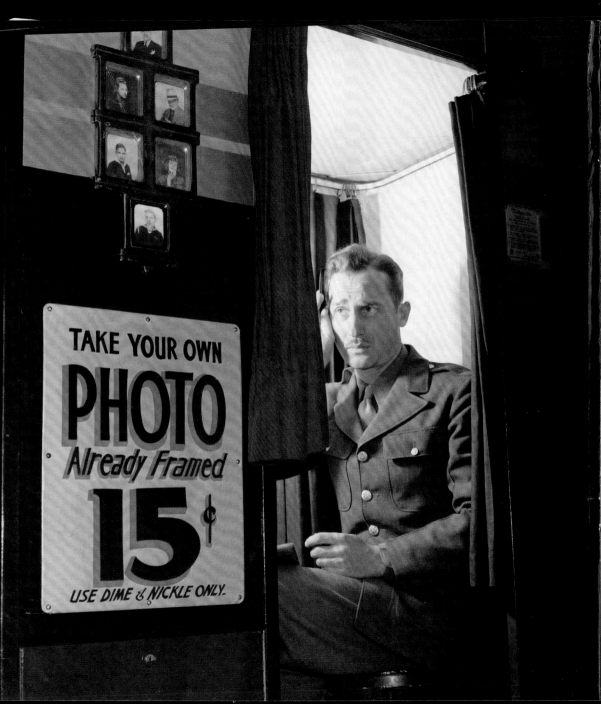

FIELDS OF VISION

The Photographs of Esther Bubley

Introduction by Melissa Fay Greene

g

THE LIBRARY OF CONGRESS, WASHINGTON, D.C.

For The Library of Congress:
Director of Publishing: W. Ralph Eubanks
Series Editor and Project Manager: Amy Pastan
Editor: Aimee Hess

For D Giles Limited:
Copyedited by Melissa Larner
Proofread by David Rose
Designed by Miscano, London
Produced by GILES, an imprint of D Giles Limited,
London
Printed and bound in China

The Library of Congress is grateful for the support of
Furthermore: a program of the J.M. Kaplan Fund

The Library of Congress, Washington, D.C., in
association with GILES, an imprint of D Giles Limited,
London

Library of Congress Cataloging-in-Publication Data
Bubley, Esther.
The photographs of Esther Bubley /
introduction by Melissa Fay Greene.
p. cm. -- (Fields of vision)
ISBN 978-1-904832-48-5 (alk. paper)
1. Documentary photography--United States.
2. United States--Social life and customs--1918–1945--
 Pictorial works.
3. Bubley, Esther.
4. Library of Congress--Photograph collections.
I. Library of Congress.
II. United States. Farm Security Administration.
III. United States. Office of War Information.
IV. Title.
TR820.5.B45 2010
770.92--DC22
[B]
2009036417

Frontispiece: A picture-taking machine in the lobby of the United Nations service center, December 1943 (detail).
Opposite: Women wait for their turn to use a boardinghouse bathroom, Washington, D.C., January 1943.
Page VI: Spectators at a parade to recruit civilian defense volunteers, Washington, D.C., July 1943 (detail).
Page VIII: Small boys watching the Woodrow Wilson High School cadets, Washington, D.C., October 1943 (detail).

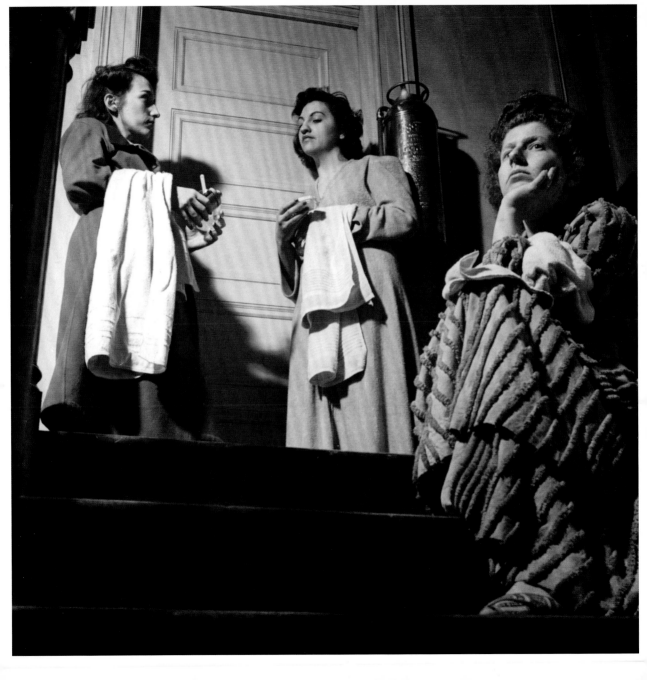

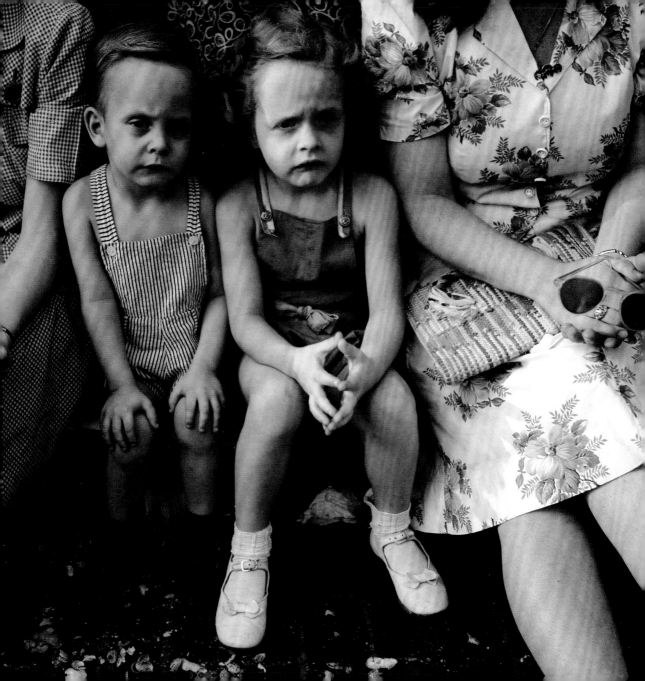

Fields of Vision
Preface

The Farm Security Administration–Office of War Information (FSA–OWI) Collection at the Library of Congress offers a detailed portrait of life in the United States from the years of the Great Depression through World War II. Documenting every region of the country, all classes of people, and focusing on the rhythms of daily life, from plowing fields to saying prayers, the approximately 171,000 black-and-white and 1,600 color images allow viewers to connect personally with the 1930s and 1940s. That's what great photographs do. They capture people and moments in time with an intimacy and grace that gently touches the imagination. Whether it is a fading snapshot or an artfully composed sepia print, a photograph can engage the mind and senses much like a lively conversation. You may study the clothes worn by the subject, examine a tangled facial expression, or ponder a landscape or building that no longer exists, except as captured by the photographer's lens long ago. Soon, even if you weren't at a barbeque in Pie Town, New Mexico, in the 1940s or picking cotton in rural Mississippi in the 1930s, you begin to sense what life there was like. You become part of the experience.

This is the goal of *Fields of Vision*. Each volume presents a portfolio of little-known images by some of America's greatest photographers—including Russell Lee, Ben Shahn, Marion Post Wolcott, John Vachon, Jack Delano, and Esther Bubley—allowing readers actively to engage with the extraordinary photographic work produced for the FSA–OWI. Many of the photographers featured did not see themselves as artists, yet their pictures have a visual and emotional impact that will touch you as deeply as any great masterwork. These iconic images of Depression-era America are very much a part of the canon of twentieth-century American photography. Writer James Agee declared that documentary work should capture "the cruel radiance of what is." He believed that inside each image there resided "a personal test, the hurdle of you, the would-be narrator, trying to ascertain what you truly believe is." The writers of the texts for *Fields of Vision* contemplate the "cruel radiance" that lives in each of the images. They also delve into the reasons why the men and women who worked for the FSA–OWI were able to apply their skills so effectively, creating bodies of work that seem to gain significance with time.

The fifty images presented here are just a brief road map to the riches of the Farm Security Administration Collection. If you like what you see, you will find more to contemplate at our website, www.loc.gov. The FSA–OWI collection is a public archive. These photographs were created by government photographers for a federally funded program. Yet, they outlived the agency they served and exceeded its mission. Evoking the heartbreak of a family who lost its home in the Dust Bowl or the humiliation of segregation in the South, they transcend the ordinary—and that is true art.

W. Ralph Eubanks
Director of Publishing
Library of Congress

Esther Bubley
By Melissa Fay Greene

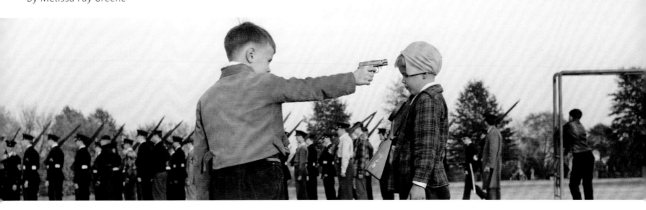

It was, to judge from the photographs, a fatiguing era for women. All that drab, oft-mended, and practical wartime clothing—wool dresses and long wool overcoats, girdles and sweaters, felt hats with small veils, and boxy suit blazers with padded shoulders—made a girl just want to lie down. And lie down they did, in Esther Bubley's photographs, flattening the curls they'd rolled and uncomfortably slept on the night before, tangling their hair and losing their bobby pins. Young women collapse and sprawl asleep on bus-terminal benches and plastic-covered couches (12, 45), in boardinghouse bedrooms (3), and on a sand beach at a Maryland pool (43). Even wide-awake women are tilting: a high-school girl leans against a tiled wall of lockers (36); a tennis player reclines against a fence (35); and a young woman—listening, we are told, to a radio murder mystery—curls forward so heavily over a cabinet, her head propped on her hand, one knee drawn in, that she seems to be suffering in some way, as if from a hangover or migraine (37). Maybe the young photographer felt weary herself, unused to the long hours on the road with cumbersome equipment; perhaps she longed for a nap of her own on a thin boardinghouse mattress with her shoes off and the curtains drawn.

Women's industry is here, too, helping to account for all that exhaustion. A tired young woman stares straight ahead with an emotionless expression; she works as a restroom attendant in a Greyhound bus station (22). A strong-armed bus-washer looks over her shoulder with a skeptical squint, scrub-brush in hand (41). Housewives loom in their kitchens, queens of their realm. "The Campbell family at home after church" (38) features a larger-than-life mother, framed by house, husband and child, dwarfing them all.

In an iconic image for the World War II era, a stylish young lady hails a bus from the shoulder of a state road in Georgia (9). Her name might be Millie, Iris, or Clara; Evelyn, Blanche, or Sophie. We can guess that she's single, about to answer her country's call for women to fill city jobs evacuated by newly minted military men. Her wave is a little tentative, but successful—the bug-eyed bus steams to a halt—then off she will go, feigning a confidence she doesn't yet possess, fleeing the family farm, the local boy, and a lifetime of animal husbandry, gardening, and canning. We could shuffle and deal out these photographs differently; we could play them face up like Tarot cards to predict the bus-hailing young lady's destiny. As the bus bumps along the state highways in the hot wind, she gazes out the half-lowered fly-specked window on fields of cotton, peanuts, onions, and tobacco—worked by sharecroppers and by shackled black prisoners under the eye of armed guards and dogs; she

dozes on her sticky plastic seat past red-clay hills and pine woods, shanties without window glass and roadside barbecue joints. When uniformed men hop aboard and stride down the aisle, duffle bags over their shoulders, she bobs awake. White soldiers and black soldiers share a kind of camaraderie she has never seen before (1). In small-town Georgia, the races don't speak to each other as equals. In some towns, Negro citizens must step into the curb to allow whites to pass by on the sidewalk.

At bus terminals in Georgia, Tennessee, North Carolina, and Virginia, along the route to Washington, the young woman sees couples embracing in melancholy farewells—will the boy survive the war? Will the girl remain faithful? They share kisses, tears, and promises—to wait chastely, to come back (10). Changing buses in Richmond, the young woman nods off for an hour on the worn wooden bench in the terminal's hot waiting room, where overhead fans lazily stir the cigarette smoke. She may get lucky and land a desk job in Washington, where she'll learn to take dictation, to file, and to shun improper advances. She'll rent a room in a boarding house, make friends, and go to an Elks Club dance. She'll wear seamed stockings, high heels, and a bow in her hair. Dancing the jitterbug will take her breath away (16). She'll try Swing and the Lindy Hop while saxophones toot and trombones holler. With black musicians and white musicians sweating together under the lights on the bandstand, this young lady knows she has truly landed hundreds of miles from the church pie-suppers back home. Perhaps she will slow-dance with a homesick young soldier and promise to write to him. In a year or two, she could be the woman boiling diapers on the gas stove while her plump baby does push-ups on a table-mat (14). Or things may take an unlucky turn, and she will find herself waiting in an all-night diner for a "date," laying out a tissue and then a small clutch purse along the bench like lures for an unsuspecting male (4). Her trap seems to be working: through the venetian blinds from the dark street, a man is peering.

* * *

It is July 1943. A parade bangs its way through the streets of Washington, D.C., with the purpose of recruiting civilian defense volunteers. Judging from the morose looks on the faces of two small citizens, it's a utilitarian parade indeed. A brother and sister, nearly identical in size, features, and clothing, wear matching expressions of malcontent (25). Squished between two women in summer dresses, visible only in torso, the miniature, dissatisfied customers obviously have been dragged here on a hot day with unfair promises and raised expectations. "A parade!" they must have been told. "Don't you want to come see a nice parade?" But there are no balloons, no marching bands, and no flavored ices, so here they endure, with corresponding creases of dismay on their faces.

Esther Bubley is here, too, of course, her back to the street. She focuses on the cranky siblings instead of the parade. Turning away from the main event, she studies its resonance in the faces and manners of the spectators. Further along the sidewalk, Bubley finds an old woman, slope-shouldered and paunchy with age, her eyes ringed by fatigue or suspicion (47). Here the photographer plays a little trick, capturing, just beyond the old lady's left shoulder, a reflection in the shop-glass of a lovely young girl. Youth and Age. The old lady and her memories: the slip of a girl she once was, the young fellas who came a-calling. Esther Bubley doesn't require a parade. She is awake to the parade of humanity. A distinctive face in the crowd and the transient emotion brushing across it are the prey for which she sets her traps. Hidden behind her camera, almost invisible to her subjects, she waits. She clicks. The secrets revealed in such moments mean more to her than the procession of servicemen and army drummers down the avenue, the stuff of ordinary picture-taking.

And the disgruntled siblings? Today they would be about the age of the droopy woman who stood near them on the crowded sidewalk sixty-six years ago, when all three failed to derive any pleasure from a martial street presentation undeserving of the name parade.

* * *

The main event in all these pictures, the twentieth century's Main Event, is World War II. Bubley didn't travel overseas during the war, but she covered the home front—again, the phenomenon of capturing truth with her back turned to the

spectacle. Enlistment, separation, fear, loss, homesickness, sorrow, patriotism, courage, and loneliness flow through these images. Grief twists the face of a middle-aged American Legion color-bearer at Arlington National Cemetery in May 1943 (31). Bubley turns her back to the ceremony to find the true cost of war reflected on the face of a man in the crowd. While his companion stands at attention (the younger man's stern expression seems to forbid emotion at this formal moment) the older man wraps his fingers around his wooden flag-pole and inclines his head towards it, as if unconsciously replaying an intimate connection to a loved one, perhaps his son, perhaps lost in the war. We need not see the staged event, the Memorial Day service at the Arlington Amphitheater. What remains now of those speeches, of that applause, of those tears? What souvenir program could touch us as profoundly as Bubley's picture of a gentle man's suffering? He can't even keep his flag upright; he pulls the pole close to him, one last time.

<center>* * *</center>

Esther Bubley was privileged, was *thrilled*, to be swept up in American photojournalism's great mid-century documentary projects: the government-funded assignments and road trips offered to a select few by the photography program of the Resettlement Administration (RA) (1935–36) and the Farm Security Administration (FSA) (1935–44), and by the photographic unit of the Office of War Information (OWI) (1942 and 1943). A group of American photographers was hired to travel and photograph New Deal programs in America on the government payroll. Given creative freedom, they fanned out across the landscape to document rural poverty, the Dust Bowl, the Great Depression, racial segregation and the signage of white supremacy ("Colored Waiting Room"), New Deal modernization and farm mechanization, and the wartime mobilization of the home front.

It was the golden age of photojournalism. Black-and-white photographs pre-dated black-and-white broadcast television, and color photographs pre-dated color television. The first vivid real-life images of the outside world reached American households not on bulbous screens housed within massive polished wooden cabinets and sold in furniture stores; the first images arrived as photographs in *Life* and *Look* magazines in the 1930s. Think "YouTube." Think "iPod touch." The world at your fingertips! Instant access to culture, sports, and far-away scenes! Brimming with full-page photos, *Life* and *Look* offered narratives in the form of photographic essays. The public—after centuries of smudged typeset columns—was hungry for pictures. There was but a handful of professional photographers capable of creating what were then called "picture-stories" for the "picture magazines." They were the website-designers of their era, the mid-twentieth century equivalents of today's graphic artists and masters of Flash, templates, and search-engine optimization. They were a talented and knowledgeable elite.

The unconventional cohort hand-picked by the brilliant Roy Stryker—the father of the documentary photography movement, an economist who headed FSA's Photographic Section—included a black man, Gordon Parks; white women, such as Dorothea Lange, Marion Post Wolcott, Marjory Williams, Charlotte Brooks, and Martha McMillan Roberts, and white men like Walker Evans, Russell Lee, Arthur Rothstein, Ben Shahn, and John Vachon. A few—Parks, Lange, and Evans—would become household names. The FSA photographers would produce an archive of a quarter of a million images. Following in the footsteps of early documentarians Joseph Ris and Lewis Hine, they cemented the foundation stones of picture-taking as a tool not only of historical record, but of social justice and (a new concept at mid-century) of art.

<center>* * *</center>

When the FSA photography project began in 1935, Esther Bubley was a teenager in Phillips, Wisconsin, the daughter of a spare auto-parts dealer and his wife. Both Louis and Ida Bubley had been part of the great migration of Eastern European Jews from Russia between 1881 and 1924. Louis was born in 1890 in the Russian city of Dvinsk (now Daugavpils, Latvia). Ida was from the smaller and poorer town of Lazdijai, Lithuania. Fifty years after Ida emigrated, the Jewish citizens of her village were rounded up by the Nazis and butchered, along with 80 percent of Lithuanian Jewry, about 200,000 people. Louis' birthplace suffered a similar fate.

Ida Gordon met Louis Bubley in Minnesota; they married in their early twenties in Hibbing. Enid was born in 1914, Anita in 1916, and Claire in 1918; after the family moved to Wisconsin, Esther was born on February 16, 1921, followed by her only brother Stanley in 1922. Enid, Anita, and Claire became an inseparable trio, while Esther and Stanley shared adventures "like twins," according to Jean Bubley, Stanley's daughter.

"My grandparents were devoted to each other," Jean told me. In photos they seem a short, stout, well-matched couple. Ida, the burlier of the two, had twin widow's-peaks and a thickly padded face. Louis, with his charcoal eyebrows, high forehead, and receding hairline, looked a bit more the intellectual. The daughters were lovely – thin-waisted triangular-faced girls with dark arched eyebrows. They wore their hair brushed and rolled back into smooth peaks and valleys. They were smart and studious, skipping grades and graduating young. Esther was enchanted as a child by her camera, a black metal cube with a handle on top like a lunchbox. She and Stanley snapped photos of neighborhood kids, developed them in their own darkroom, and sold the prints to the children's parents.

Esther was a petite fifteen-year-old high-school senior in Superior, Wisconsin, with her mother's hairline and her father's arched brows when, on November 23, 1936, the first issue of *Life* hit the newsstands. Margaret Bourke-White took the cover photo of Fort Peck Dam in eastern Montana. Esther, like her older sisters before her, was named editor-in-chief of the high-school yearbook. As a result of the deep impressions made on the young editor by Bourke-White and *Life*, Central High's 1936–37 yearbook probably set a high-water mark for graphic design, creative layout, and gritty realism. Esther snapped students and faculty in candid shots, and then laid out the pictures at steep angles across the pages. If the finished work didn't quite rival America's newest magazine, it set Esther on the path she would follow for the rest of her life.

* * *

Nineteen-year-old Esther Bubley arrived in Washington, D.C., in 1941, after spending two years at Superior State Teachers College (now the University of Wisconsin-Superior), one year working at a photo-finishing lab in Duluth, Minnesota, and one year studying photography at the Minneapolis School of Art (now the Minneapolis College of Art and Design). Unable to find a photography job in Minneapolis, she joined Enid, a nurse, and Claire, a court reporter, in Washington. Esther's journey didn't differ much from those of the bus-hailing, bus-terminal-bench-napping, boardinghouse-snoozing, or jitter-bugging young women she would soon document. She, too, was a modern young woman defying convention, setting off from the provinces for the capital to make her fortune. But she couldn't find a photography job in Washington either, so she tried New York City, where she had a brief stint photographing nightclub acts (and fending off the advances of the nightclub owner) and a briefer one taking pictures of gifts for the 1941 *Vogue* Christmas issue, which ended when, according to Bonnie Yochelson and Tracy A. Schmid in *Esther Bubley on Assignment*, "she shattered an expensive glass vase by placing floodlights too close to it and was not rehired."

Bubley returned to Washington in the spring of 1942 and found a job microfilming documents for the National Archives. Over-qualified for the task, politely wearied by the clumsiness of her inept co-workers, she caught the eye of her supervisor, Vernon Tate, who happened to be a friend of Roy Stryker. Stryker's FSA Historical Section had just been moved to the Office of War Information. The OWI was charged with educating the public at home and abroad about the conduct of the war (the Voice of America radio network was founded under this initiative, and hundreds of newsreels and radio broadcasts were created) and with documenting the country's mobilization. Styker offered Bubley a job in the OWI darkroom and introduced her to his crack team of photographers. Esther later wrote: "Dorothea Lange, Russell Lee, Jack Delano, Ed and Loiuse Rosskam and others became not just names, but friends and in a sense teachers."

Stryker evidently glimpsed the steely and ambitious artist within Esther. With his encouragement, she tried her hand at a photo essay about her sister Enid's boardinghouse. The picture of the girl lying down next to her radio is probably Enid (Claire's children think it is Claire) (3). Esther's accompanying

written essay, "Life in a boardinghouse in Washington D.C." has survived, showing her to be a clever and observant writer as well as picture-taker. One of Bubley's now-famous images (p.V) shows impatient young women (including Enid at left) waiting outside the closed door of the bathroom, towels at the ready. The angle tells of their arduous climb to reach this spot—so near the summit, yet waylaid. There is no eye contact, nor chit-chat. Each woman is focused on her mission, the tasks ahead. Esther captured them in prose, too:

> Time in the bathroom is supposed to be strictly scheduled in the morning. Each floor has its own system—for instance each person on the third floor is allowed seven minutes in the bathroom in the morning. Occasionally an uncooperative person will move in the house. Then there is the line up at the door. One girl, in spite of convention and precedent, took her leisurely time in the mornings, ignoring irate pounding on the door and all pleas and threats. For this, a sin more grievous than B.O., she was socially ostracized, and when she moved in a month, no one was on speaking terms with her.

Stryker admired the boardinghouse photo essay and promoted Bubley to field photographer. Within the year, she gave him 2,000 images and was acknowledged as an equal by the OWI photographers.

* * *

Esther Bubley didn't drive a car, so she gratefully accepted Stryker's assignment to travel cross-country by bus for six weeks to capture America in transition between the Great Depression and World War II. What she documented were private moments in the lives of the bus-riders and how the large changes afoot in the world were altering and shaping individual lives. She wrote charmingly about her adventures, too. Esther was a marvelous oral historian, taking notes fast enough to capture cadence and colloquialism, annoyance and humor.

When creating her wartime body of work in prose and pictures, Bubley was a slender, soft-spoken, unobtrusive, curly-haired Midwestern Jewish girl in her twenties. She was so polite and unassuming, in fact, that *Life* magazine initially refused to hire her despite her outsize talent. "Your pictures are wonderful," *Life* picture editor Ray Mackland told her, "but you just don't have a *Life* personality." He was looking for something more along the lines of a "tall, square-jawed, racket-toting Ivy Leaguer," someone more aligned with the "power elite."

But her apparent shyness allowed her to approach closely; she asked her subjects' permission to take their pictures; they said yes, then forgot about her. She believed they grew "bored" with her. Once, on assignment from the *Saturday Evening Post* to take pictures of a certain family at home, she expressed the need to scale their bookcase and shoot from above. Up she climbed, and there she crouched, looking like a character from a Thurber cartoon, while her subjects went about their business.

Mackland, at *Life*, finally bowed to the obvious when Esther won a *Life*-sponsored photo contest; she became a regular contributor to *Life*, starting in 1951, and eventually sold forty photo stories, including two cover stories, to that periodical. In the postwar years, she followed Stryker to Standard Oil of New Jersey and documented the Texas oil boom; she followed him again to the Pittsburgh Photographic Project for a series on the city's Children's Hospital. In 1947 she married Edwin Locke, Stryker's administrative chief, divorced him quickly, and never spoke of him again. Instead, it seems, she found love, intimacy, and happiness in brushing close to humanity through the lens of a camera. "I have found the human race," she wrote in her journal in 1953 in Rome, Italy. "It is like finding one's family at last."

Her reputation grew. She worked for *Ladies' Home Journal*, *Look*, the African American magazine *Our World*, *McCall's*, and *Harper's Bazaar*. Her pictures graced more than thirty covers of the government journal, *The Child*. She traveled on assignment to Europe, Central America, South America, Europe, North Africa, Australia, and the Philippines. She documented mental illness and the confines of psychiatric hospitals, emergency surgery, tenant farmers, teenage ingénues, high school drop-outs, children's choirs, and New York City children playing in the spray of open fire hydrants. Following Miss America contestants backstage, she captured them applying lipstick, rolling their hair, squeezing into their gowns. She photographed Pulitzer Prize-

winning poet Marianne Moore in a wide-brimmed hat beside an elephant, visited baggy-eyed Albert Einstein on the occasion of his seventy-fourth birthday, and shot a jam session with Charlie Parker. For the National Foundation for Infantile Paralysis, she created posters, as well as a dozen photo-essays included in the "How America Lives" series for *Ladies' Home Journal* between 1948 and 1960. She traveled to Turkey for Pan-American World Airways, and to Draa Valley, Morocco, with a UNICEF medical mission. One of her Moroccan photographs won first prize in *Photography* magazine's 1954 competition. The first woman to win, Bubley was given a trophy with the figurine of a male photographer.

Throughout her career, she racked up the awards; she was respected by peers as one of the best, one of the brightest lights of photojournalism's golden era. In her later years, cocooned in her Upper West Side apartment with her Dalmatian, Sheba, she read murder mysteries and science fiction, was visited by a small circle of close friends, and continued to make pictures, especially of her dog and her houseplants. Bubley died of cancer on March 16, 1998, survived by her sisters Claire and Anita.

* * *

For all of her seriousness about photography, Esther Bubley's mischievous sense of humor emerges in many of her photographs. Stryker encouraged all his photographers to capture the signs of the era, but he probably did not have in mind the sign at the National Zoo: "*LOST CHILDREN and articles found will be taken to the LION HOUSE*" (7). The warning is made funnier, ludicrous, by the very fact of her photographing it. The smaller sub-heading, "*Losses should be reported there*," adds to the absurdity with its hint of grieving parents whose children have been fed to the lions. In "Women gossiping in a drugstore over cokes" (6), a stern older woman seems to be breathing fire upon the younger woman. Her cigarette smoke billows threateningly around her companion as she holds forth. The bent-back brim of the younger woman's hat lends the impression that the dragon-lady's fumes have nearly blown it from her head. "Inside the terminal during a Greyhound bus trip" (19) shows a father, in a fedora, holding a baby who is wearing an extremely

pointy cap. In the name of documenting wartime bus travel Bubley created a photograph that could have been captioned "Birth of the Cone-heads" or "American father raises alien child." "Greaseball, a mascot, at Stevens Airport" (26) shows a small pup nearly ready for take-off, his ears angled in the breeze like the wings of the airplane behind him.

In my favorite photograph of Esther's dog Sheba, the huge head of the half-dozing Dalmatian lies close to a book. She has gnawed off about ten percent of the cover. If you turn the picture upside down, you can read the name on the spine: "Training You to Train Your Dog." Like Sheba, Esther Bubley chewed up the instruction manual and spat it out. She remained untamed, creative, surprising, and funny to the end, a genius in black-and-white.

1

Soldiers looking out the window of the bus in the Greyhound terminal, Washington, D.C., April 1943.

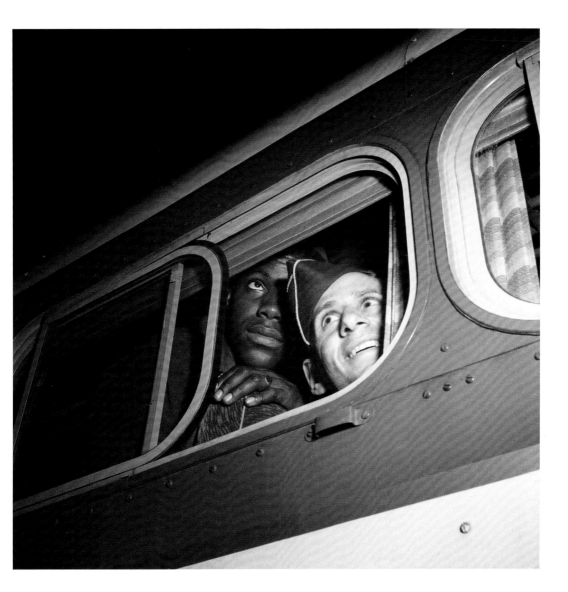

Soldier in front of the Capitol Theatre, Washington, D.C., March 1943.

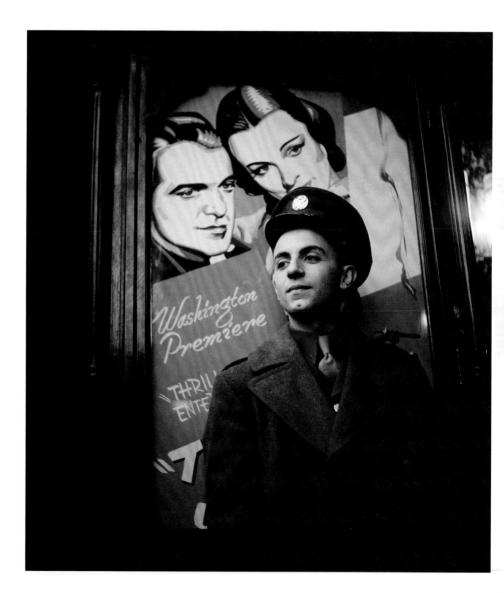

3

A girl listening to the radio in her boardinghouse room, Washington, D.C., January 1943.

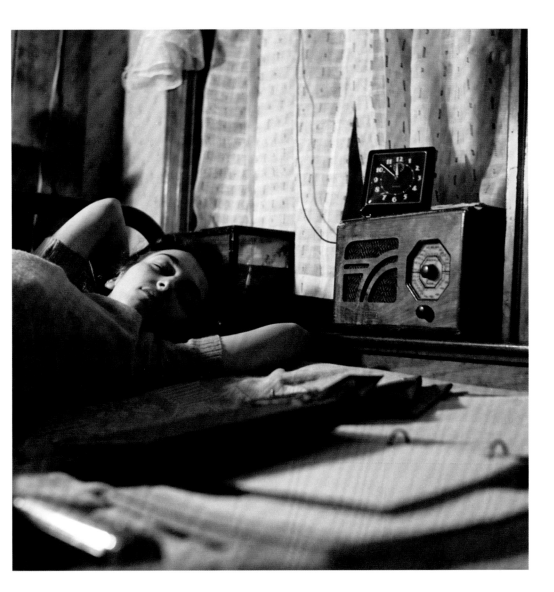

4

Girl sitting alone in the Sea Grill, a bar and restaurant, waiting for a pickup, Washington, D.C., April 1943.

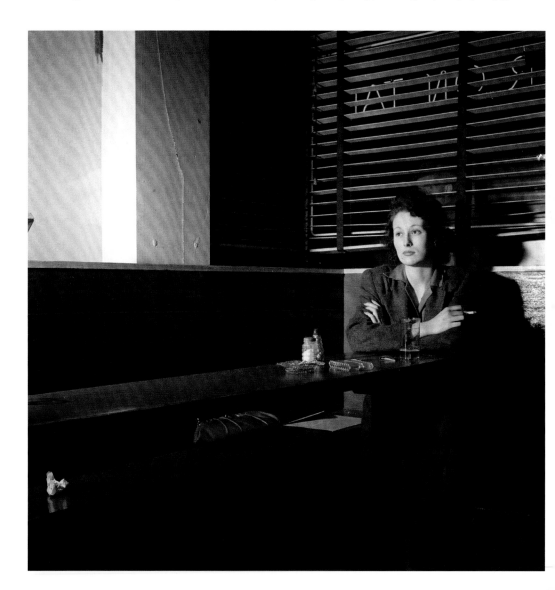

5

Greyhound bus passenger sitting in the terminal on a trip from Louisville, Kentucky, to Memphis, Tennessee, photograph taken in Chattanooga, Tennessee, September 1943.

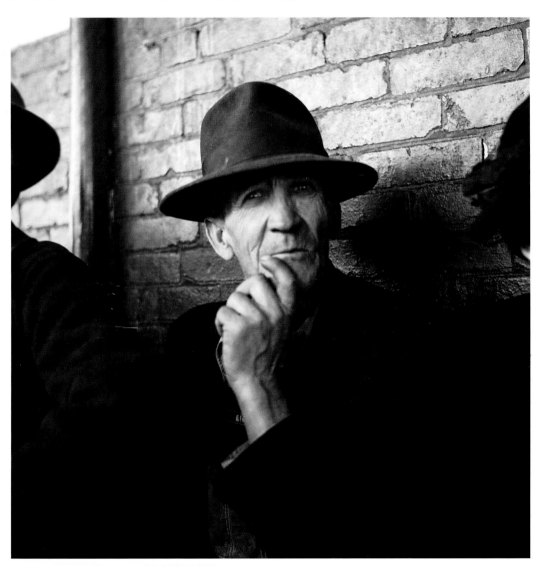

6

Women gossiping in a drugstore over cokes, Washington, D.C., March 1943.

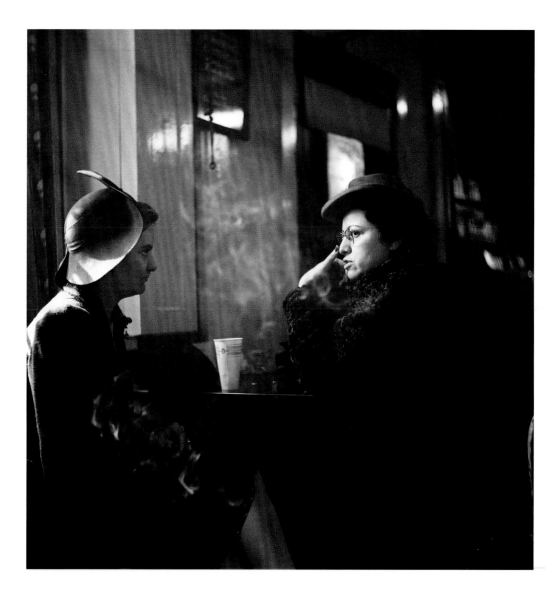

A sign at the National Zoological Park, Washington, D.C., May 1943.

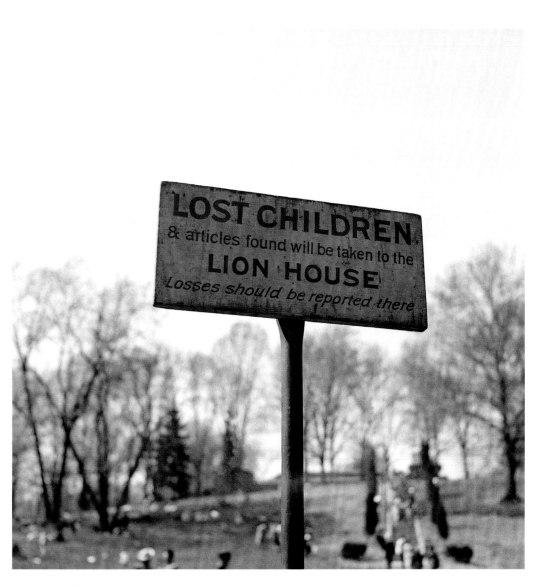

An African American church, Washington, D.C., April 1943.

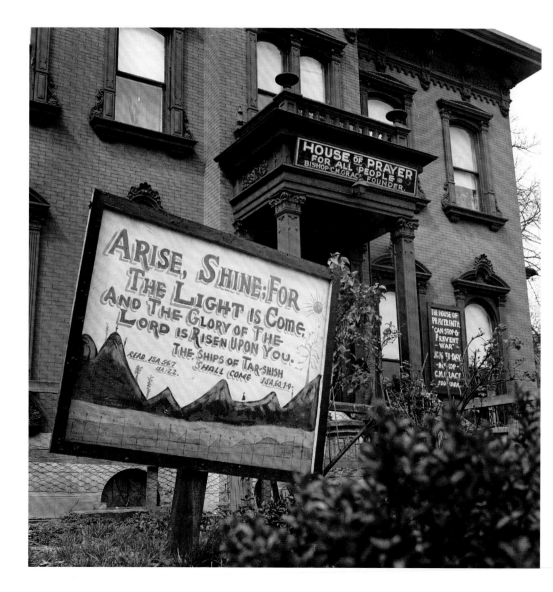

9

Hailing a Macon-bound bus on the highway in Georgia, September 1943.

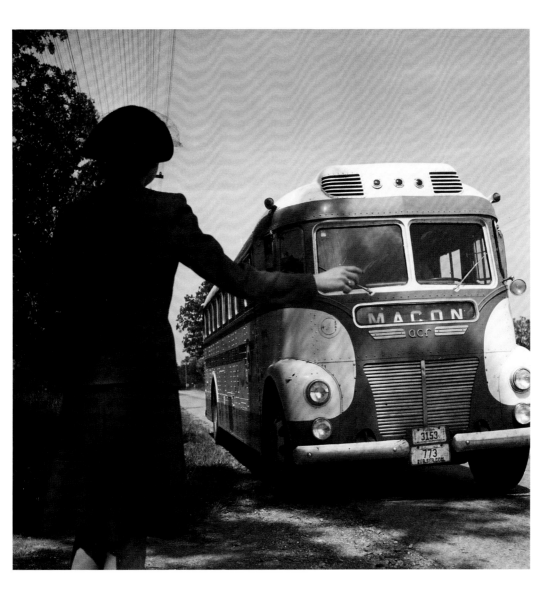

Soldiers with their girls in front of the Greyhound bus, Indianapolis, Indiana, September 1943.

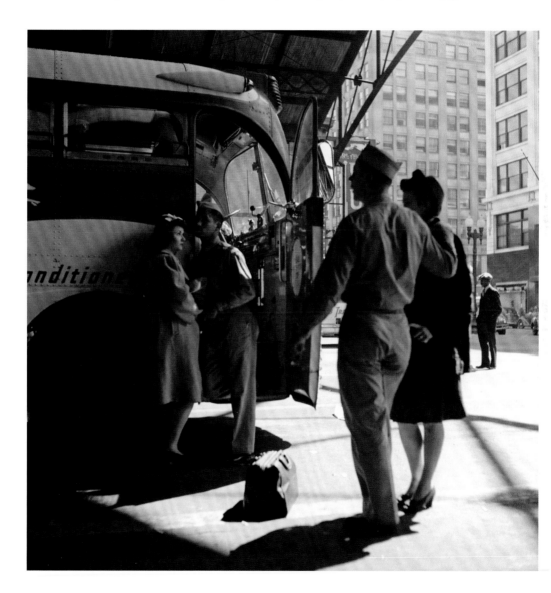

Outside the United Nations Service Center, Washington, D.C., December 1943.

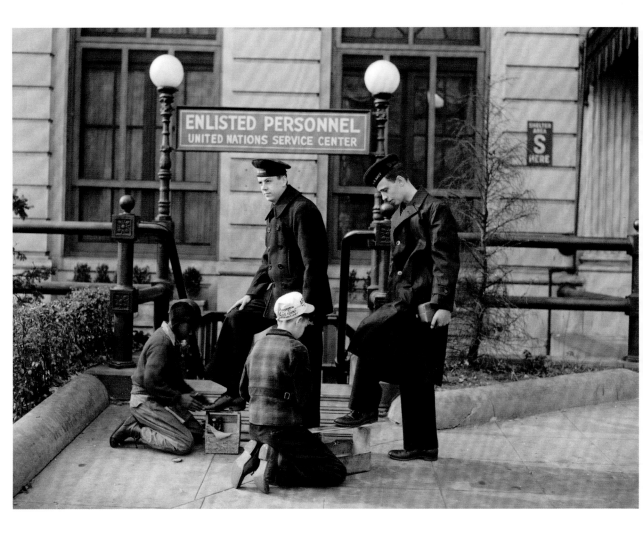

Girls sleeping in the waiting room of Union Station, Washington, D.C., March 1943.

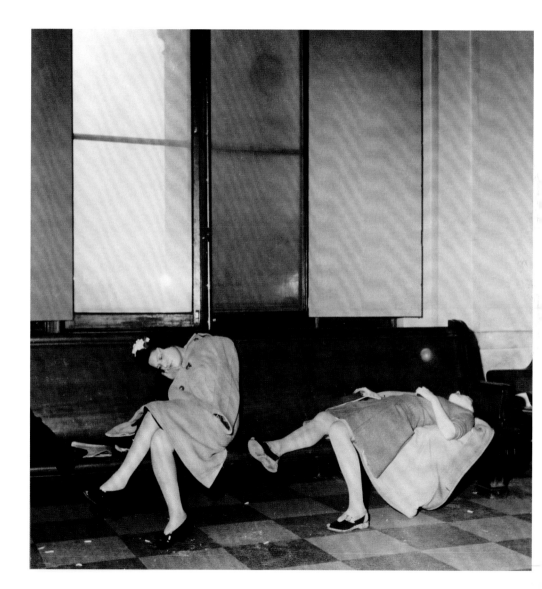

In one of the dormitory rooms at the United Nations Service Center, Washington, D.C., December 1943.

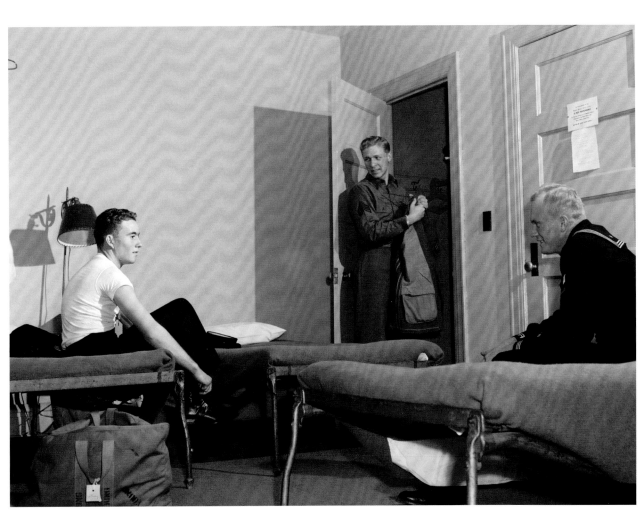

Lynn Massman, wife of a second class petty officer, doing the washing, Washington, D.C., December 1943.

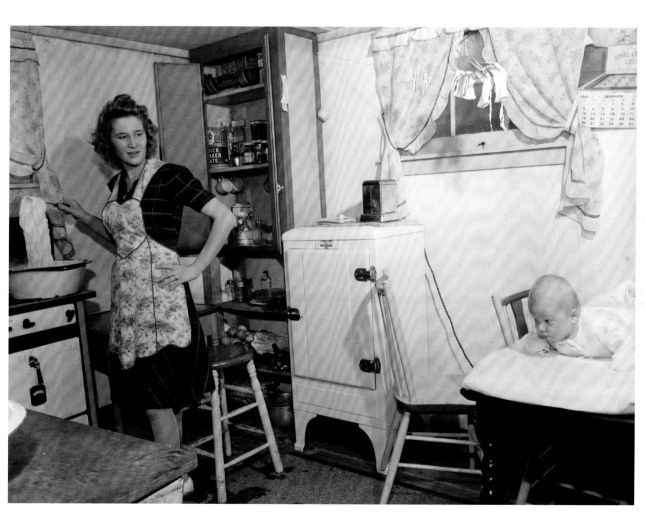

A student from Woodrow Wilson High School wearing saddle shoes, Washington, D.C., October 1943.

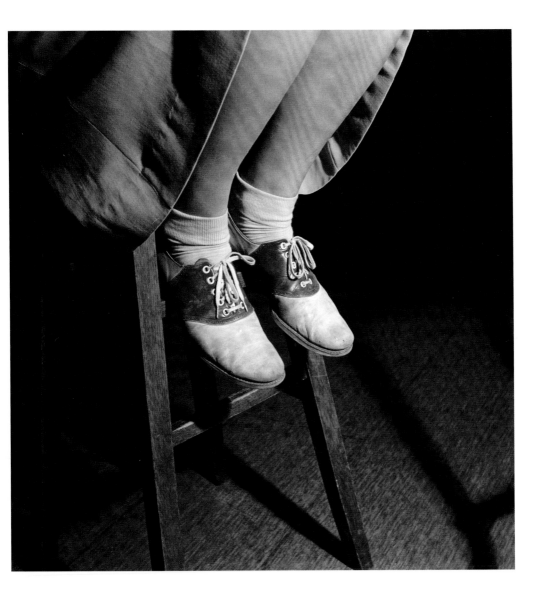

Jitterbugging at an Elks Club dance, Washington, D.C., April 1943.

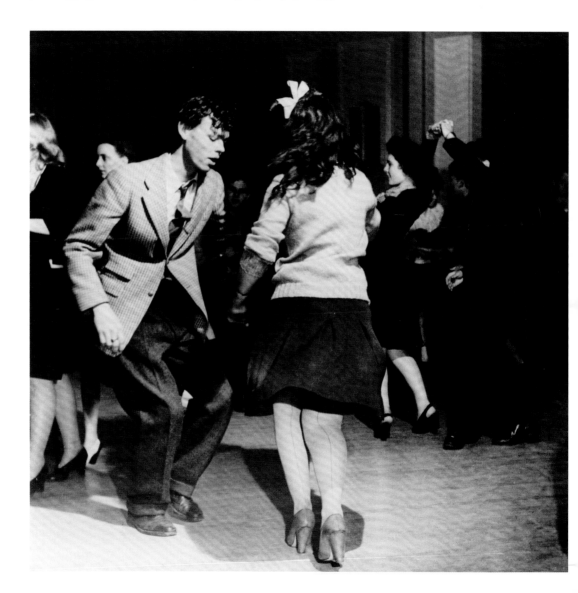

Pin boy at a bowling alley, Washington, D.C., April 1943.

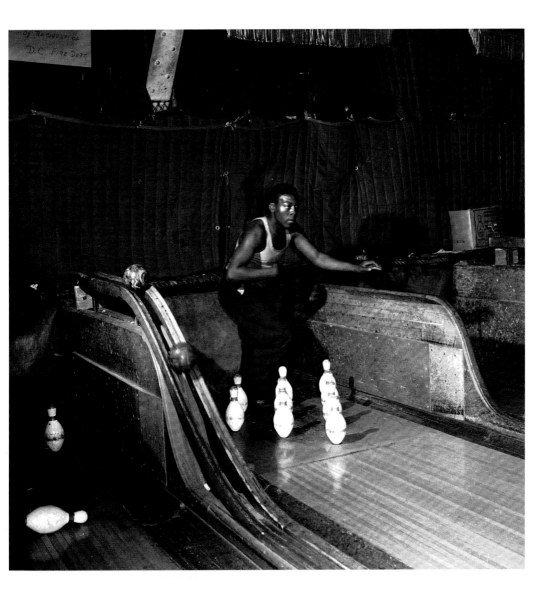

18

Walter Spangenberg and his date at the regimental ball held at Woodrow Wilson High School, Washington, D.C., October 1943.

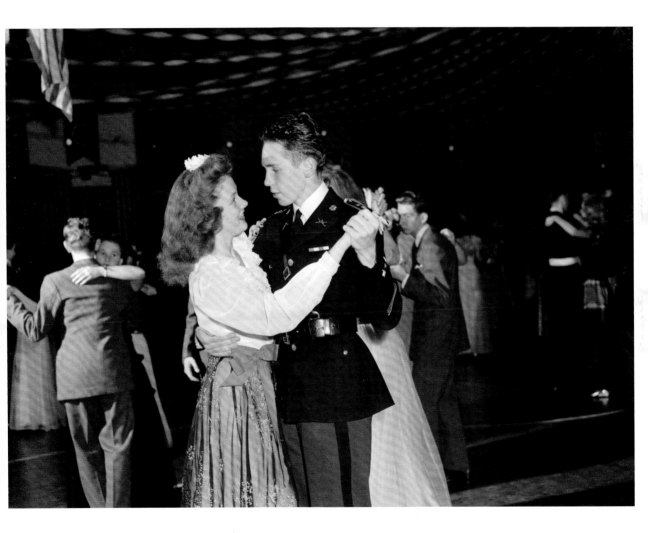

Inside the terminal during a Greyhound bus trip from Louisville, Kentucky, to Memphis, Tennessee, September 1943.

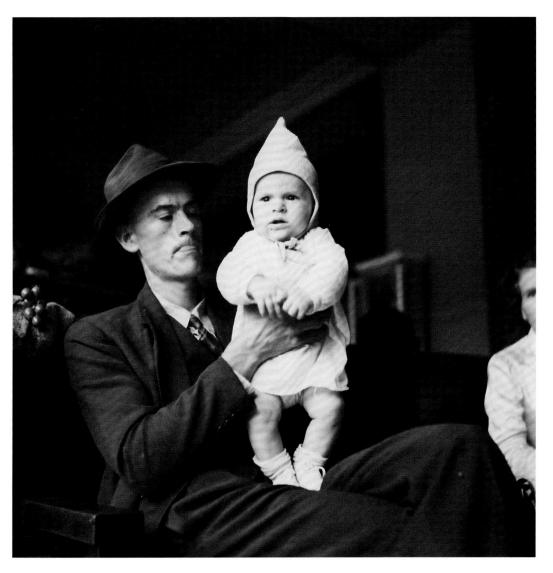

The terminal during a Greyhound bus trip from Louisville, Kentucky, to Memphis, Tennessee, September 1943.

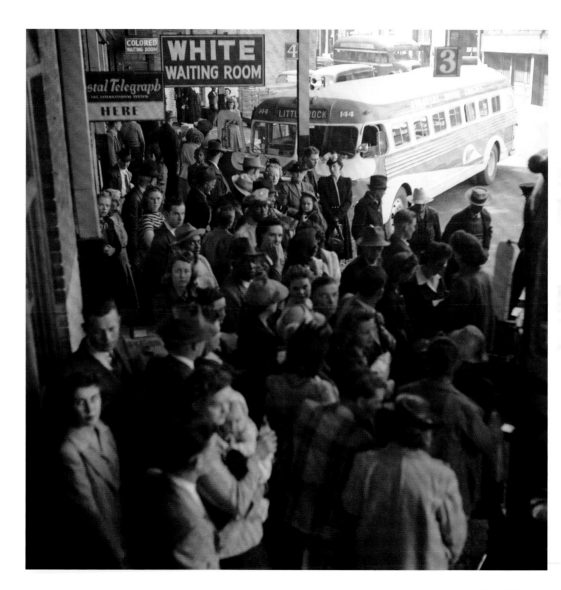

Alley dwellings near the Capitol, Washington, D.C., July 1943.

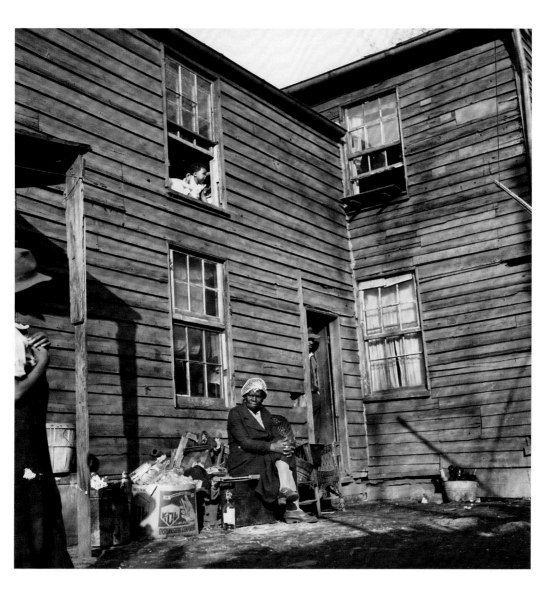

A maid in the women's restroom at the Greyhound bus terminal, Cincinnati, Ohio, September 1943.

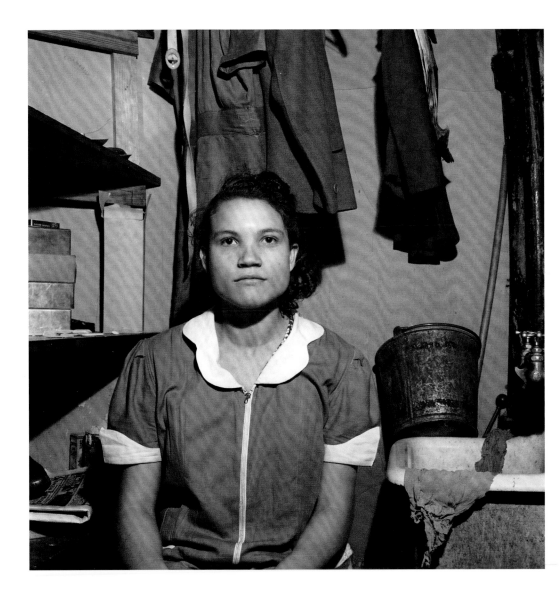

An eating place near the Greyhound bus stop, New Bedford, Pennsylvania, September 1943.

A rest stop for Greyhound bus passengers on the way from Louisville, Kentucky, to Nashville, Tennessee, with separate accommodations for African American passengers, September 1943.

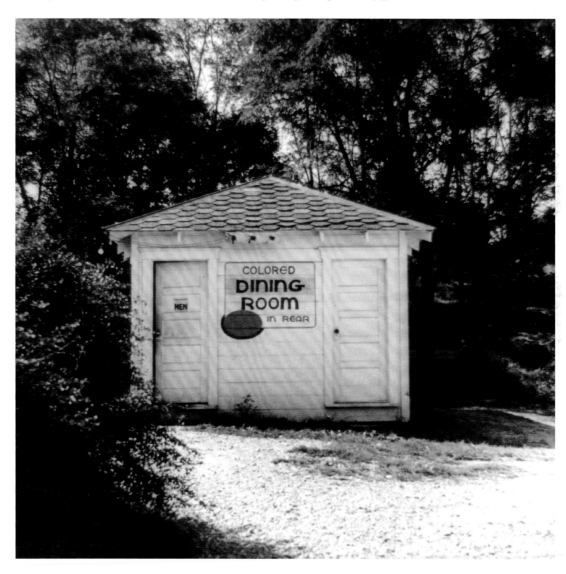

Spectators at a parade to recruit civilian defense volunteers, Washington, D.C., July 1943.

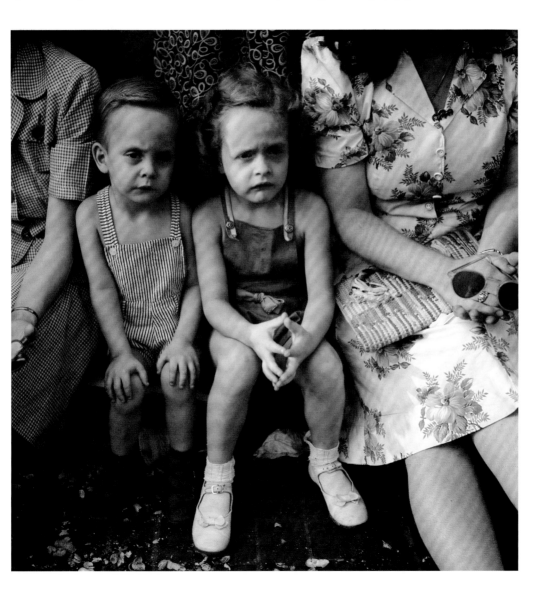

Greaseball, a mascot, at Stevens Airport, Frederick, Maryland, October 1943.

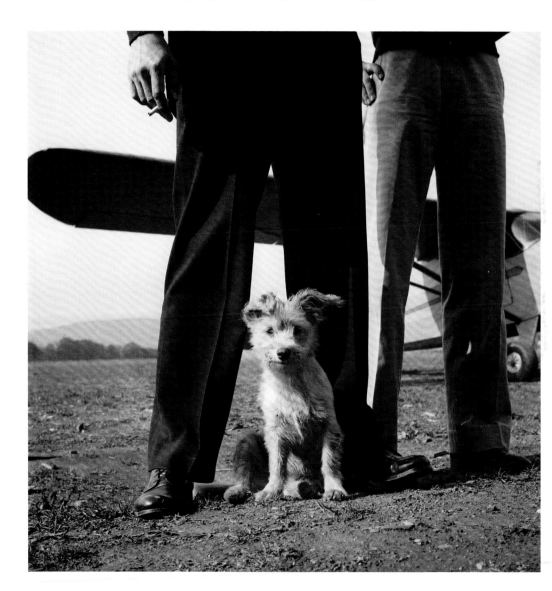

Small boys watching the Woodrow Wilson High School cadets, Washington, D.C., October 1943.

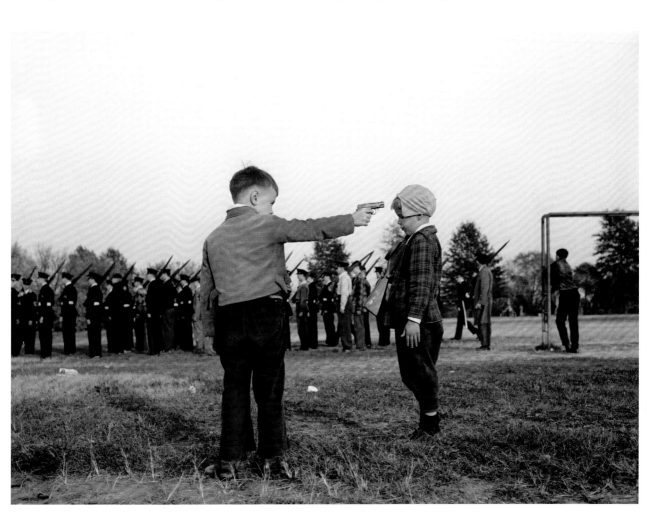

Decorating a soldier's grave on Memorial Day, Arlington Cemetery, Arlington, Virginia, May 1943.

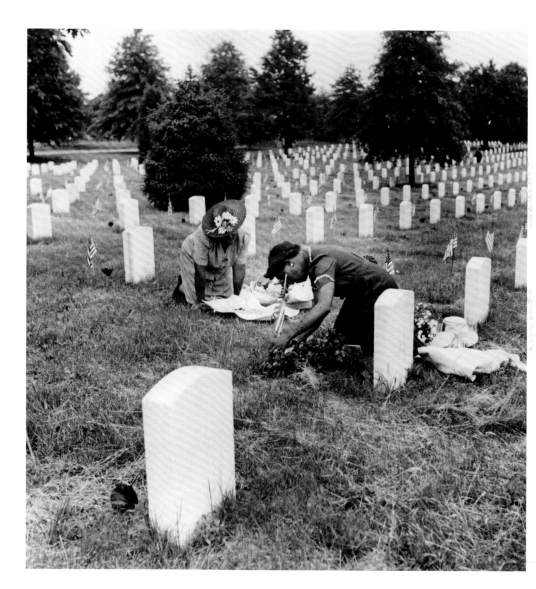

Sign for Silent-Nite tourist rooms offering free lodging to soldiers in uniform, between 1940 and 1946.

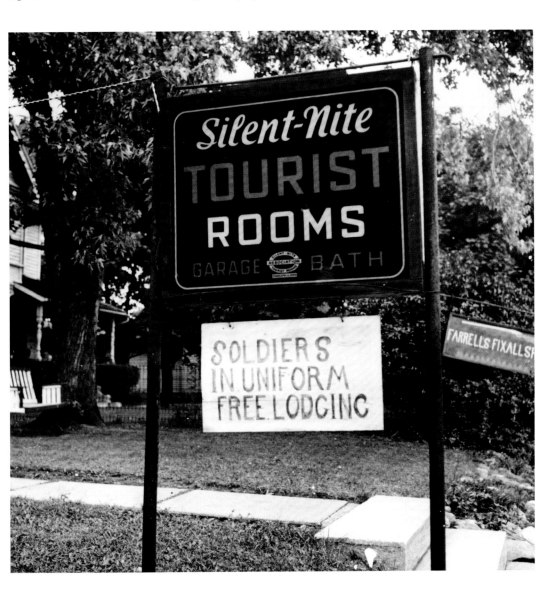

Sign at a bus station on a Greyhound bus trip from Louisville, Kentucky, to Memphis, Tennessee, photograph taken in Rome, Georgia, September 1943.

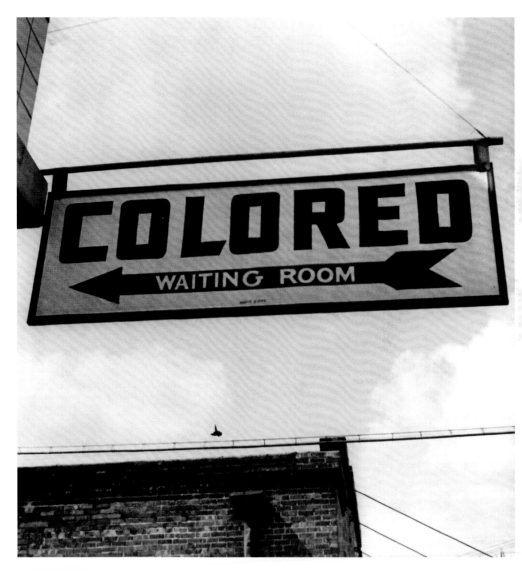

American Legion color bearer, during the Memorial Day services at the amphitheater, Arlington Cemetery, Arlington, Virginia, May 1943.

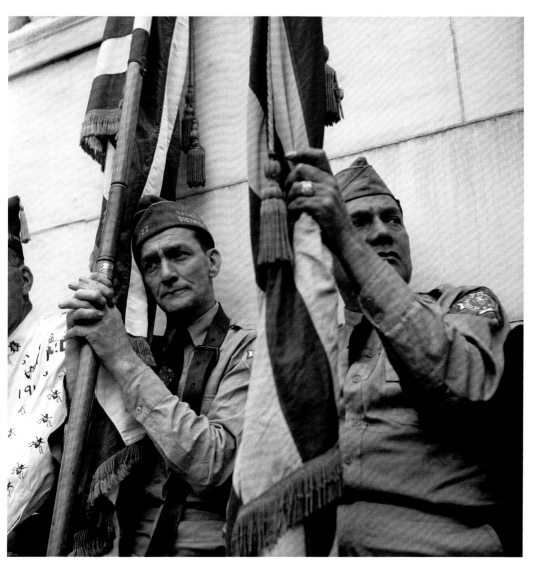

Spectators at a parade to recruit civilian defense volunteers, Washington, D.C., July 1943.

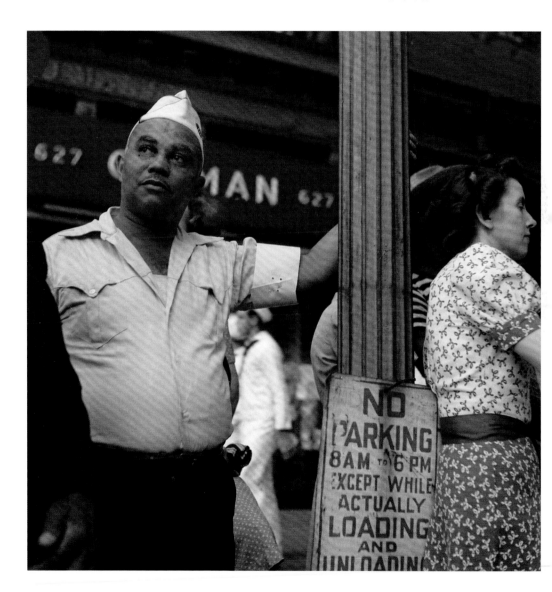

Children at the National Zoological Park, Washington, D.C., May 1943.

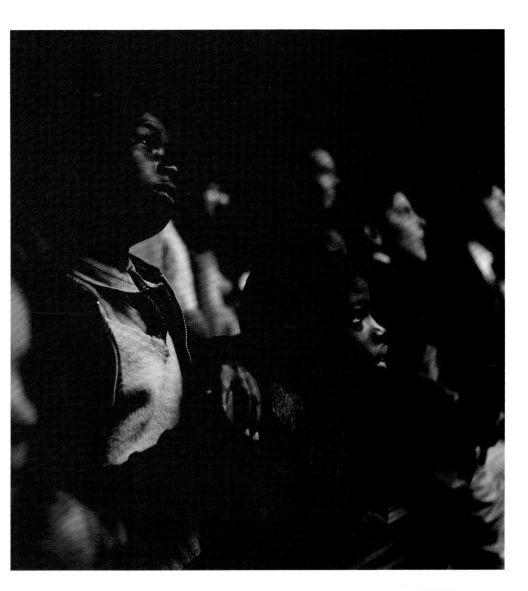

34

A boy in the King's Court section of Washington, D.C., April 1943.

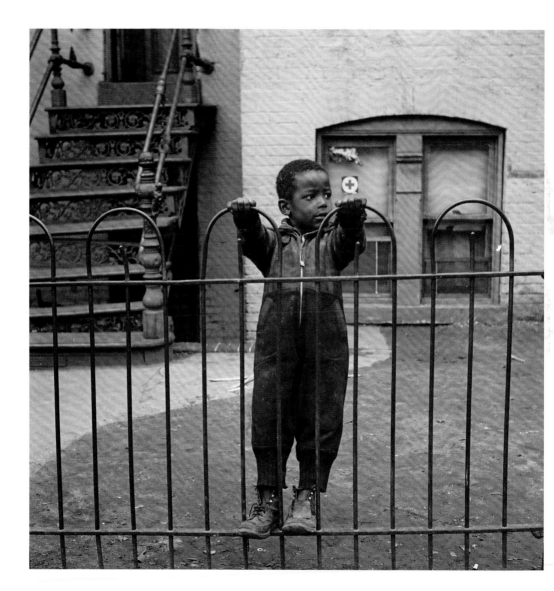

A Woodrow Wilson High School student waiting to use a tennis court, Washington, D.C., October 1943.

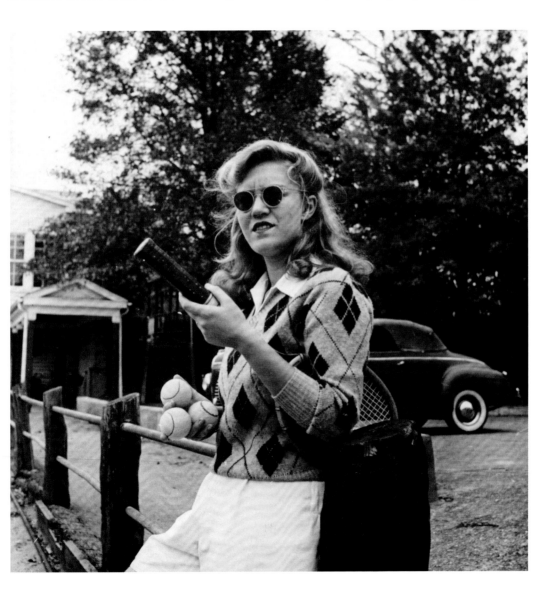

A student at Woodrow Wilson High School, Washington, D.C., October 1943.

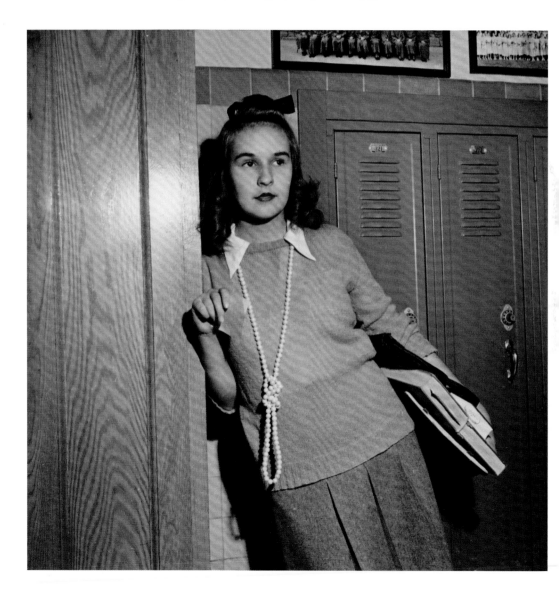

Listening to a murder mystery on the radio in a boardinghouse room, Washington, D.C., January 1943.

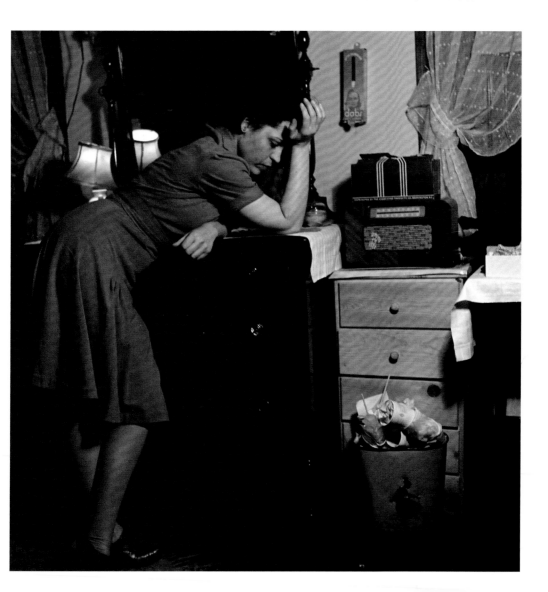

38

The Campbell family at home after church, Washington, D.C., March 1943.

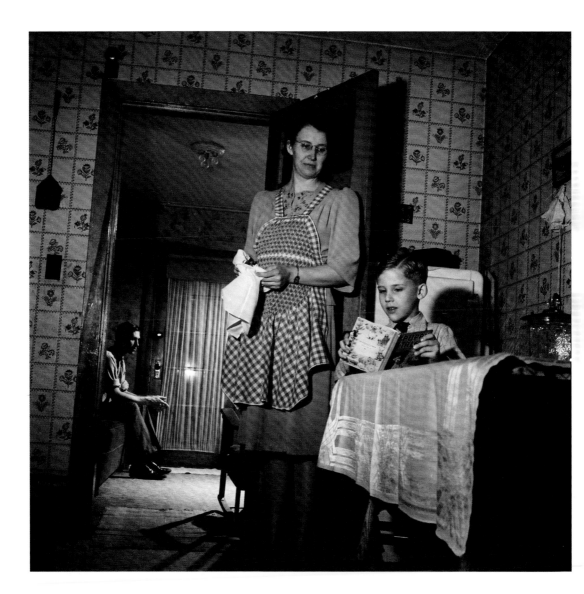

Boy Scout color bearer listening to the Memorial Day ceremony, Arlington Cemetery, Arlington, Virginia, May 1943.

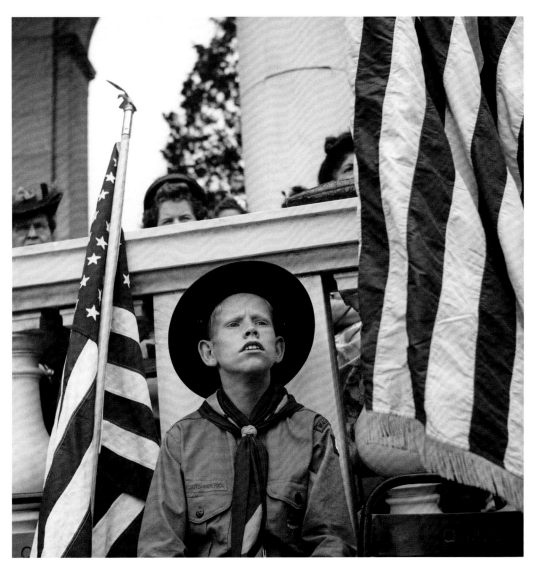

Listening to the U.S. Army band play at a free concert in front of the Capitol, Washington, D.C., June 1943.

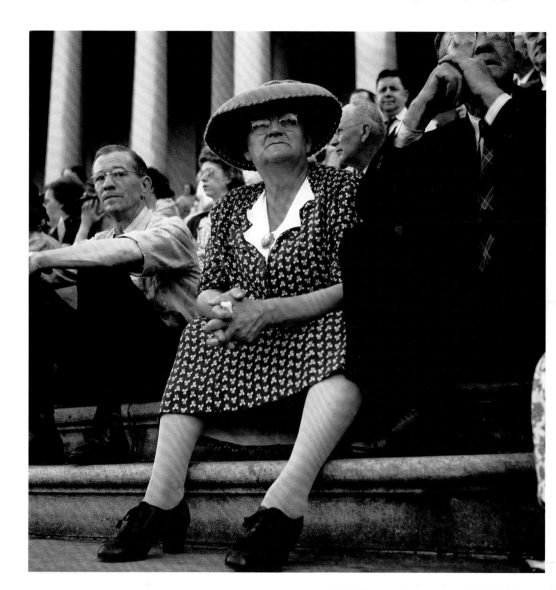

Woman cleaner at the Greyhound garage, Pittsburgh, Pennsylvania, September 1943.

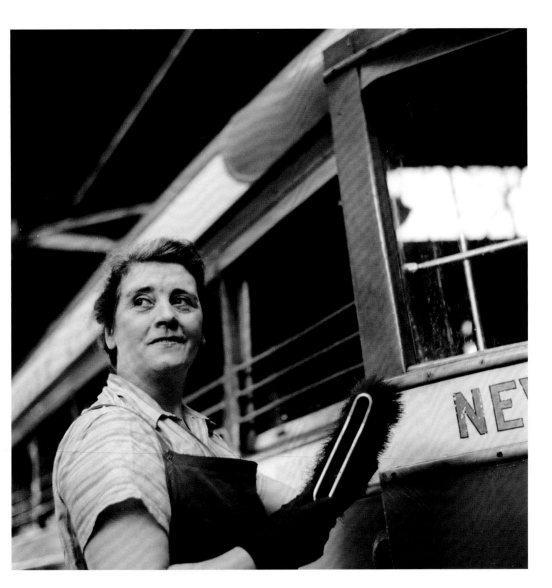

A picture-taking machine in the lobby of the United Nations Service Center, December 1943.

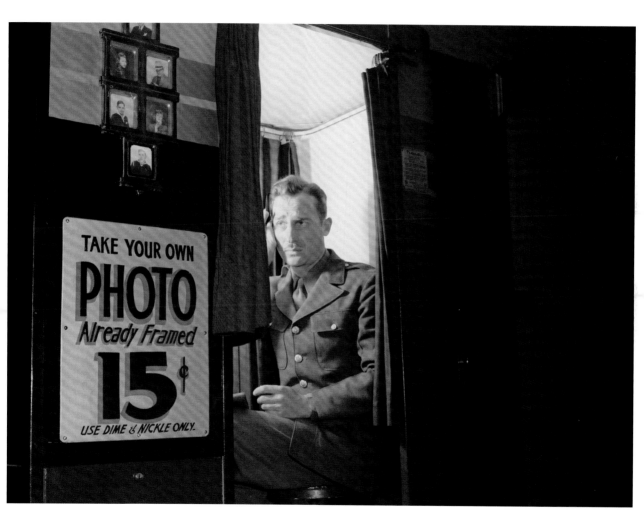

Sun bathers on the sand beach at the swimming pool in the Glen Echo amusement park, Glen Echo, Maryland, July 1943.

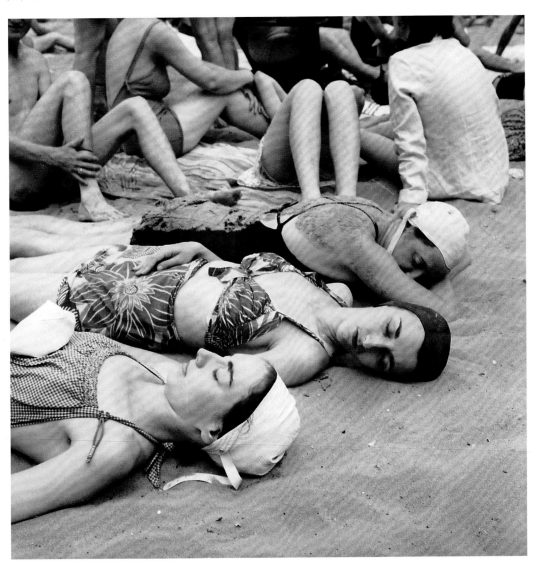

A soldier sleeping on a Greyhound bus traveling from Cincinnati, Ohio, to Louisville, Kentucky, September 1943.

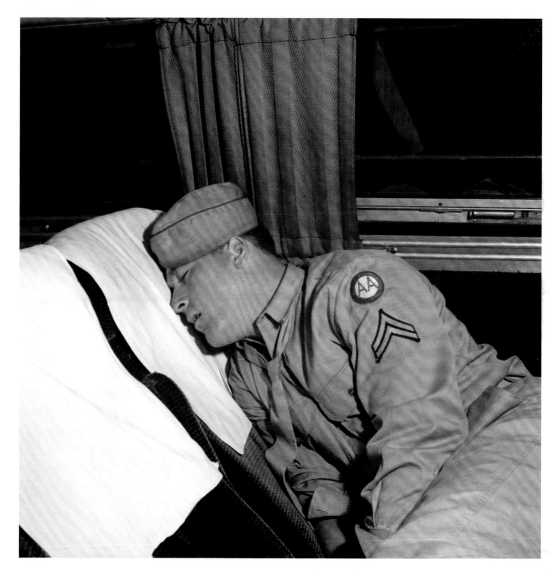

A girl waiting between buses in the ladies' lounge of the Greyhound bus terminal, Chicago, Illinois, September 1943.

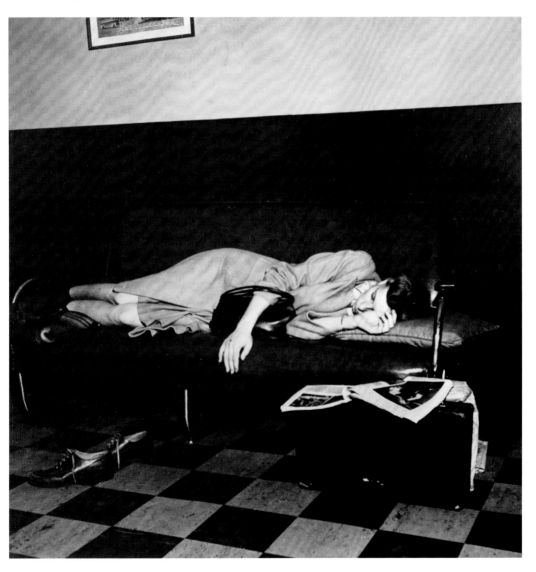

A Greyhound bus station, Indianapolis, Indiana, September 1943.

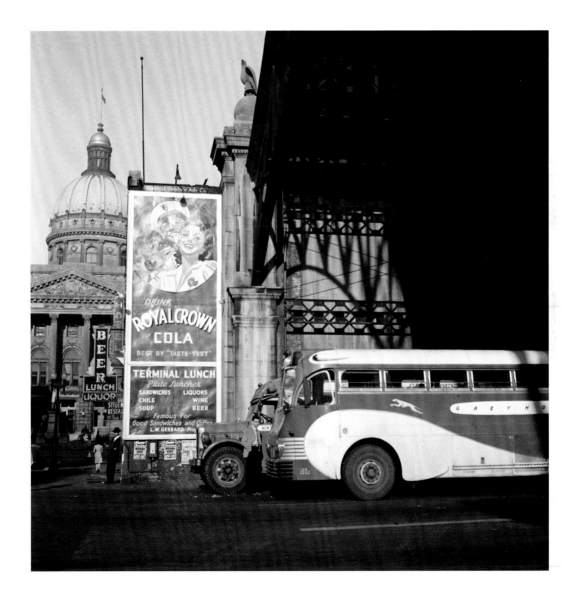

A worker for the American Rescue Society soliciting funds, Washington, D.C., July 1943.

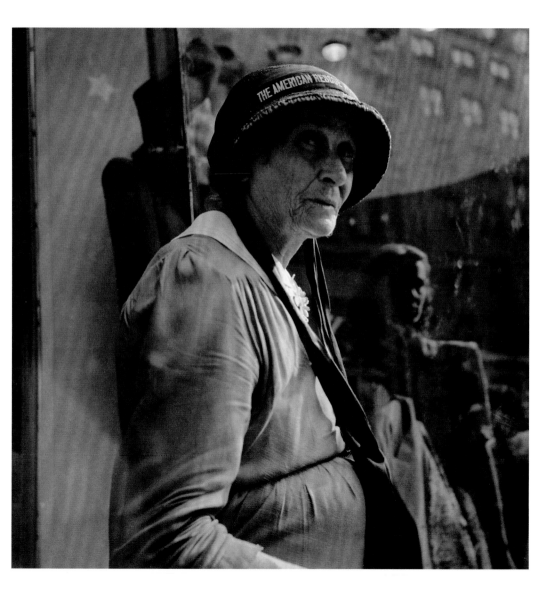

A small boy waiting in the terminal on a Greyhound bus trip from Louisville, Kentucky, to Memphis, Tennessee, photograph taken in Chattanooga, September 1943.

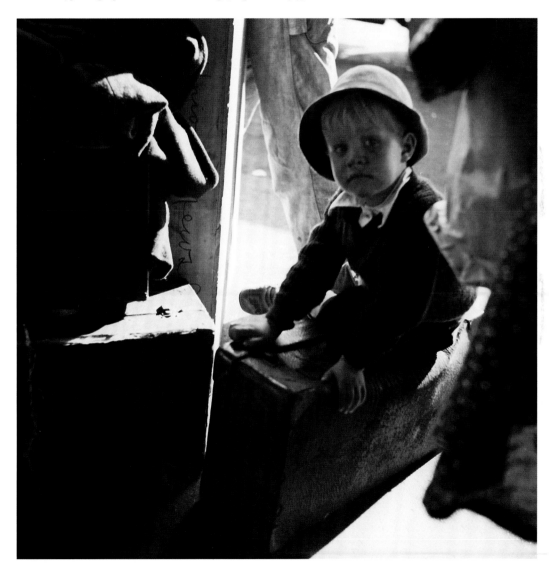

A statue in Lafayette Park, Washington, D.C., December 1943.

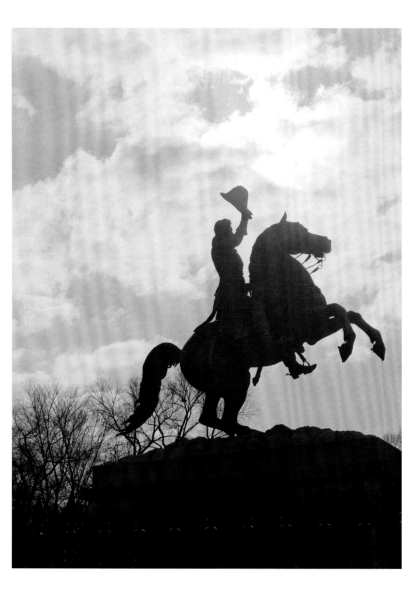

In front of Union Station, Washington, D.C., December 1943.

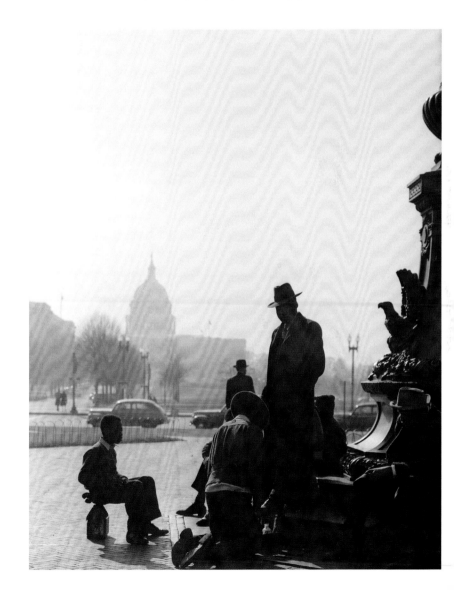

Images

The images in the Farm Security Administration–Office of War Information (FSA–OWI) Photograph Collection form an extensive pictorial record of American life between 1935 and 1944. In total, the collection consists of about 171,000 black-and-white film negatives and transparencies, 1,610 color transparencies, and around 107,000 black-and-white photographic prints, most of which were made from the negatives and transparencies.

All images are from the Library of Congress, Prints and Photographs Division. The reproduction numbers noted below correspond to the page on which the image appears. Each number bears the prefix LC-DIG-fsa (e.g., LC-DIG-fsa-8a16183). The entire number should be cited when ordering reproductions. To order, direct your request to: The Library of Congress, Photoduplication Service, Washington, D.C. 20450-4570, tel. 202-707-5640. Alternatively, digitized image files may be downloaded from the Prints and Photographs website at http://www.loc.gov/rr/print/catalog.html.